New York November 1911

				2450	4259550

We purchased this painting from the
Collection of Mrs Joseph of London

Credit.
Ptg by Rembrandt 21⅛ × 27⅜ oval p.
Port. of a Man in a broad brimmed
hat and ruff. Signed + dated 1633.
" " Rembrandt 21⅛ × 27⅜ oval p.
Port. of a Woman in white Cap and
ruff Signed + dated 1634 ℔175,000
Smk. 119 44/5

15

C. K. G. Billings
 5 Wall St.
Ptg. by C. H. Miller 32 × 24½
 The Water Cart II 1881 ℔ 300
M.K.C. Sale 1893 No. 21
J. Gerrity

L. M. Flesh

The Collector as Patron in the Twentieth Century

PART ONE

The Collector as Patron

An exhibition of postwar paintings from the collections of
Bea and Phil Gersh, Agnes Gund, Marieluise Hessel,
Bebe and Crosby Kemper, Mary and Jim Patton

Irving Sandler, Curator

PART TWO

Profiles in Patronage

An archival exhibition featuring American collector-patrons
from Henry Clay Frick through mid-century

DeCourcy E. McIntosh, Curator

May 2 through July 31, 2000

Knoedler & Company

— ESTABLISHED 1846 —

19 East 70th Street New York 10021 Tel (212) 794-0550

For their gracious support of *The Collector as Patron in the Twentieth Century,* Knoedler & Company wishes to thank Dana Cranmer of Cranmer Art Conservation, Russell Gerlach of Gerlach Frames, Jeffrey Haber of Acordia Northeast, and *The Art Newspaper*, media sponsor for the opening reception at The Frick Collection.

© 2000 Knoedler & Company
Library of Congress Catalog Card no. 00-103091
ISBN: 0-615-11639-6

Design: Lawrence Sunden, Inc.
Printing: Meridian Printing

CONTENTS

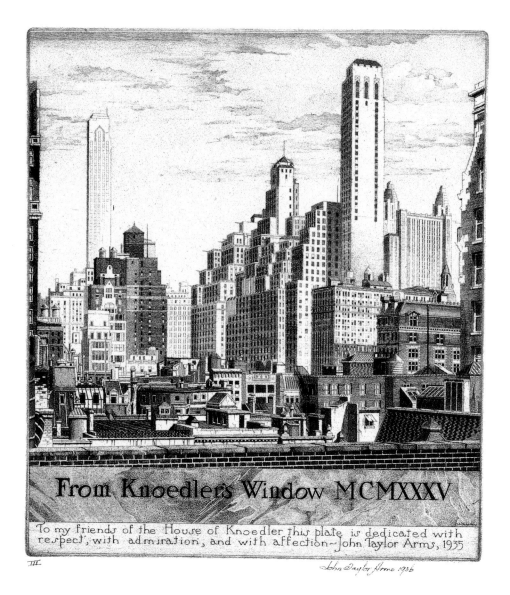

From Knoedler's Window MCMXXXV

To my friends of the House of Knoedler this plate is dedicated with respect, with admiration, and with affection~John Taylor Arms, 1935

III. John Taylor Arms 1936

John Taylor Arms (1887–1953), *From Knoedler's Window MCMXXXV*. Etching commissioned in 1935 by M. Knoedler & Co., Inc. (then at 14 East Fifty-seventh Street). Reproduced actual size.

Knoedler & Company Archive

Foreword

EVERYONE ENJOYS A STORY that opens with "Once upon a time . . . ," and this is just the way the history of collectors' patronage actually began. In 1743, Anna Maria Luisa de Medici—who was both a princess and the last of the famous Medici—gave her vast family collection to form the Uffizi in Florence. Her generosity created the first-ever public art museum, and thus originated the concept of the collector as patron, an idea that happily has continued right to our own day.

Nowhere else in the world has private patronage of the visual arts had such a powerful influence as it has had in the United States. Without the benefit of royal, religious, or state-sponsored patronage found in other nations, civic-minded American collectors have long felt the need to contribute to the formation and growth of our leading museums, both the encyclopedic urban institutions and the smaller regional public galleries. From the early gifts that launched The Metropolitan Museum of Art (1870), to the magisterial Frick Collection (1935), to the present-day examples of enlightened patronage, as illustrated by this exhibition, the extraordinary vision and generosity of individuals have forever shaped and enriched our public trust.

Collectors have often used the phrase "a gift to oneself" to describe a new acquisition—that valued work of art which can generate both pleasure and insight. Collectors' patronage, as evidenced in this presentation, is a broader and extended form of this "gift"—the considered development of a collection (evolving over many years) and its careful placement in the most appropriate institution or institutions.

I have been a part of Knoedler & Company for almost a quarter of a century and feel privileged to be directing an institution that, for more than 150 years, has moved in step with the art and the collecting of its time. The long view *From Knoedler's Window* (see page 6) has provided us with a unique perspective on the building of many great collections in the United States—collections that have gone on to become important components of our major museums or even, as in the case of The Frick Collection, to become major museums in themselves. Therefore, it seems particularly fitting that Knoedler present this exhibition on the central role of collectors' patronage in the last century. The definition of patronage may well fit a new model in the twenty-first century.

The Collector as Patron in the Twentieth Century is organized in two parts. In the lower gallery, "Profiles in Patronage" traces aspects of patronage in America from 1900 to mid-century, including the contributions of the foremost benefactor, Henry Clay Frick. This archival journey is complemented by a presentation in the main gallery of significant postwar paintings from the collections of five prominent living patrons, featuring promised gifts to important American museums.

While this exhibition can only begin to explore this fascinating and underexamined subject, we trust it provides an informative and rewarding overview. Indeed, because of constraints of space and time, numerous noteworthy patrons are not to be found in this exhibition. Also, while Knoedler & Company has acted as a conduit for countless works of art that are now exhibited in public collections around the country, in this exhibition we have broadened the perspective by including works from collections that were not shaped through the gallery.

Of course one cannot adequately discuss the contribution of the patron without also acknowledging the seminal role of the art museum. David E. Finley, the first director of the National Gallery of Art, Washington, D.C., perhaps stated it best:

> Art museums, as well as science and history museums, have an educational role that is of the greatest importance . . . In one respect the museum has a great advantage over the schools. It teaches mostly by means of objects, rather than the printed book. And this is a most appealing way of acquiring knowledge . . . The art museum has another function. It is one of the few stabilizing forces in a changing world. In museums, such as the National Gallery and others, we have a sense of continuity with the past. The really great works of art never lose their vitality and, when seen in relation to those of other ages and other peoples, they help us to form some concept of the world in which we live and the civilization we have inherited . . . In a museum we are not impressed by ideologies so much as by human genius, with the result that we acquire that respect for personality and for the dignity of the individual which is at the very foundation of our Western civilization . . .[1]

This exhibition celebrating the collector as patron has been made possible by many dedicated people, beginning with Michael A. Hammer, Chairman of the Board of Knoedler, whose enthusiastic support for the gallery and its special activities is invaluable.

Irving Sandler, preeminent authority on postwar American art, has selected the paintings included in the exhibition and contributed to this publication with a most insightful essay. Irving held many hours of productive conversation with the collector-patrons at their homes, as reflected in his probing interviews. Edye Weissler, our librarian, devoted tireless effort to the complete transcription of the interviews, which have now been added to the gallery's "living" archive.

DeCourcy McIntosh, Executive Director of the Frick Art & Historical Center in Pittsburgh, has profiled many of our nation's great early collectors. These profiles grace both the exhibition and the pages that follow here. Dick's scholarship and extensive research over the years in the Knoedler Archive have made him an authority on the gallery's early history. He has indeed become an honorary member of the Knoedler Gallery family. Lynn Abraham, our dedicated guest associate curator, intelligently and thoroughly researched the multitude of subjects represented in the archival exhibition, not just in the Knoedler Archive and Library, but in numerous institutions in New York and beyond. Also, the many documents and photographs gathered from lenders across the country would not be present were it not for her resourcefulness, efficiency, and perseverance.

All of us involved have benefited from the crucial, ever-ready direction of Melissa De Medeiros, who can best be described as Knoedler's expert in-house historian and this project's "guiding light." The initial concept for this exhibition could not have evolved and matured without Melissa's extraordinary focus and dedication.

For this special occasion, our small gallery staff has been enhanced by a diverse team of curators, advisors, and designers. They have pooled their remarkable resources and talents into a collaborative effort fueled by genuine spirit and enthusiasm.

Beyond the walls of 19 East Seventieth Street, we also gratefully acknowledge the constant support, management, and understanding of our project consultant, Jeanne Collins. Her creative team, most notably her valued writer and editor Lucy O'Brien, have conscientiously helped to bring this project to fruition. Amy Forman and Roger Westerman, our exhibition designers, and Larry Sunden, the catalogue's designer, have contributed their special skills to make this presentation visually engaging.

Down the block, at The Frick Collection, I especially want to thank our neighbor Director Samuel Sachs II, who early on, warmly embraced the concept for this exhibition. I also want to acknowledge Martin Duus, Director of Development, and Robert Goldsmith, Deputy Director, for their advice and cooperation. From the Frick Art Reference Library, Patricia Barnett, Andrew W. Mellon Librarian, and Inge Reist, Chief of Collec-

tion Development and Research, have been central to the support of our joint collaboration. Roland Knoedler (the gallery's second director) and his contemporary Henry Clay Frick would be smiling today to know that we continue to celebrate our treasured relationship, now with neighboring addresses on Seventieth Street.

I thank Knoedler's Honorary Committee for its belief in the message of this exhibition. Each member of the committee is in his or her own right a shining example of patronage and all have made significant philanthropic contributions.

Last—but foremost—*The Collector as Patron in the Twentieth Century* is made possible by those outstanding collectors who have shared not only their personal experiences but have also shared their promised gifts included in this exhibition: Bea and Phil Gersh, Agnes Gund, Marieluise Hessel, Bebe and R. Crosby Kemper, and Mary and Jim Patton. Their sterling examples of patronage are a profound inspiration to the entire art community.

The concept of the collector as patron began with Anna Maria Luisa de Medici, the last Medici princess, and "Once upon a time . . ." Clearly, the public generosity of each of these extraordinary collectors demonstrates that the story of patronage, rich in tradition and great in legacy, is a model for each new generation of collectors—and the story continues . . . now and "happily ever after."

Ann Freedman
President

1 David E. Finley. *A Standard of Excellence: Andrew W. Mellon Founds the National Gallery of Art at Washington, D.C.* (Washington, D.C.: Smithsonian Institution Press, 1973), p. 177.

The Collector as Patron

by Irving Sandler

ALFRED BARR, the founding director of The Museum of Modern Art once asked, with more than a touch of irony, why people collect modern and contemporary art. "Acquisitiveness? Financial speculation? Social or cultural prestige? Competition with other collectors? The pleasure of arousing envy? The excitement of feeling in the avant-garde? The satisfaction of annoying one's conservative friends? The *noblesse oblige* or *richesse oblige* to serve as a patron of the arts for the benefit of artists and the community? Perhaps even the love of art?" [1]

For collectors who are also patrons, the answer to Barr's question is both the love of art and a desire to serve artists and a wide community. Knoedler & Company honors five of these collector-patrons for their public-spirited contributions to American life with an exhibition of works from their collections. They are Bea and Phil Gersh, Agnes Gund, Marieluise Hessel, Bebe and R. Crosby Kemper, and Mary and Jim Patton. Many other distinguished benefactors could have been chosen, but space limitations restricted the choice.

Collector-patrons are a special breed. As serious collectors, they wish to amass as many works as possible that they admire and can afford. As patrons, they want to give them all away. To understand these seemingly contradictory urges, it is necessary to examine both sides of their practice.

WHAT MOTIVATES the serious collector to acquire a work of art? The answer, simply put, is the need to own an inanimate thing that elicits a profound emotional and/or intellectual response. As such, the object of desire has magical powers, like those of a fetish, icon, or reliquary. The art object can literally bewitch the viewer. Casting a spell, it can transform him or her, that is, summon up a fresh perception of art, life, and the world, and even cause the viewer to feel, think, imagine, and act in new ways. Intense interaction with a work induces a desire to possess it in order to be able to recapture and reexperience the initial aesthetic epiphany. Passion leads to possession, the need to live with the magic of an artwork.

Wanting to find out what motivates the collector-patrons selected for this exhibition, I interviewed them. They all told me that they acquire what deeply stirs them. Occa-

sionally, they do purchase what is needed by the institution they support, but even in this they tend to choose what appeals to them. They take into account whether the work they desire will fit into their homes. After all, they have to live with it. They also trade information with artist, dealer, collector, and curator friends—people who share their interests and passion. In fact, most of their acquisitions would accord with an art-world consensus of what is liveliest and best in modern and contemporary painting and sculpture. But, as Crosby Kemper said, the deciding consideration is the "wow" factor.

With respect to our four married collector-patrons, who has had the deciding voice? The Kempers, Pattons, and Gershes buy as couples. Bea Gersh said with a smile: "It's a bonding experience." It is noteworthy that Bebe Kemper and Mary Patton are artists themselves. Agnes Gund chooses what to acquire, but she asks for the approval of her husband, Daniel Shapiro, himself a collector of African terra-cottas and Chinese art, as he does of her for his purchases.

Because they trust their own tastes, our collector-patrons frequently have bought—and continue to buy—the works of young and unrecognized artists. They have done so in order to keep themselves youthful. But they are also motivated by the awareness that their purchases are useful to artists at the point in their careers when they most need support. At the time of purchase, many of these unknown artists are considered mavericks, even by the avant-garde, but they go on to achieve art-world and public acclaim. The early recognition of new talent by our collector-patrons is a sign of—and a tribute to—their individual "eye," their open-mindedness, and their self-reliance.

Our collector-patrons collect broadly, both younger as well as long-established artists (who are featured in this show). None has a program. As Marieluise Hessel said: "I'm a pluralist person." They tend to prefer paintings and sculptures, however. They are not especially interested in conceptual art, and art-theoretical issues rarely intruded themselves in our conversations. They do require that a work of art stimulate and provoke thought, but they respond more to its sensuous and aesthetic qualities. Consequently, our collector-patrons tend to favor art that continues and renews the tradition of Western painting and sculpture, including art that may have once been considered iconoclastic. Agnes Gund summed up this attitude best when she said: "I like works that incorporate the past but are new."

Psychotherapists are divided as to whether collecting is a neurotic obsession or a positive quest for enriching experiences. I asked our collector-patrons how they viewed their desire to collect. Had it become an addiction, and was that good or bad? Agnes

Gund replied: "People have said it's a disease. And I think, oh no, I'm not like that. Then I count up what I've bought in a year, thinking that it's maybe ten, and when I realize how much I've gotten, I know that I've been bitten." But, as Bea Gersh commented, and she spoke for our other collector-patrons: "It's a pleasure, but a little bit of an addiction." Phil Gersh added: "A good addiction. It's not like smoking."

As a whole, a collection is an imaginative ensemble. It becomes a kind of surrogate or extended self, affirming the owner's identity. Choosing what to acquire provides value and meaning to the collector's life and a method of self-definition. As Marieluise Hessel commented, a collection becomes an emotional and intellectual autobiography. Kasimir Malevich once said that art must become the content of life. For the participants in this show it has. But, if our collector-patrons live through art, the life of art depends on them, since art is kept alive both figuratively and physically by those who cherish it.

Installation is important to all of our collector-patrons, even in homes so crammed with art that the order is bewildering. Works are juxtaposed so that they "converse" with one another in the language of their owners' sensibility—a subjective language that transcends styles and dates. Some of the connections among works are plain. For example, Bebe Kemper pointed to the coupling of nudes by Bonnard and de Kooning in one space; in another, portraits by Rubens, Corot, and Degas hung in close proximity. Other associations are so ineffable that they can only be sensed—but they are present.

Contemplating the art of our collector-patrons in their homes, I thought of that other great acquisitor, the museum. What were the differences? Private collectors are motivated primarily by their individual responses. Museum curators must take into account the requirements of their institutions and their various constituencies, the wishes of other staff members, and the public interest. A gallery—the white cube—in a museum dissipates any extra-aesthetic charge, whether religious, political, or personal. A collector's living space introduces the perception of its occupants and provides the art they own with a personal potency. Nonetheless, they all view the museum as the ultimate repository of their holdings.

WHY DID OUR collectors become patrons? When I asked Crosby Kemper whether there was a thrill in acquiring works of art, he responded that there is also a thrill in giving. Underlying philanthropy in the United States are peculiarly American values. Foremost is the belief that each citizen must assume personal responsibility for the welfare of

the community. As Jim Patton commented: "We were taught to live up to certain standards." He went on to say that money, if one is lucky enough to have it, provides the means for doing good in the cause of a higher purpose during one's lifetime. A concomitant value is individualism—the conviction that it is the individual that does the good, and gets things done. This belief is also linked to the commitment to free enterprise. Above all, our collector-patrons believe that philanthropy is the obligation of the wealthy in a democratic America. This attitude is unlike that of most countries in which governments are the primary funders of the arts.

Supporting a public institution by donating art is different from writing checks. As Walter Benjamin has pointed out, the ownership of objects is the most intimate relationship that one can have with them. It is simply more meaningful to part with something of personal significance—a piece of one's identity—than it is to give away money. In donating objects that one is attached to emotionally and intellectually, the private is made public. Rarely do the two come so close together.

But giving is not sufficient for our collector-patrons. They also volunteer their services to the institutions they support. Philanthropy becomes work. They do as well as give. Agnes Gund is president of New York's Museum of Modern Art. Bard College is Marieluise Hessel's "work." The Kemper Museum is Bebe and Crosby's "joy." Since the late 1950s, the Gershes have been involved with the Pasadena Art Museum, the Contemporary Art Council of the Los Angeles County Museum of Art, and The Museum of Contemporary Art, of which Bea is a trustee. Jim Patton serves on the boards or advisory committees of the Ackland Art Museum, the Aspen Museum, the Whitney Museum, and the Smithsonian Institution.

THE PASSION FOR ART induces collector-patrons to learn as much as they can about the subject, and they invest considerable time in the pursuit of knowledge. Indeed, the interest in education is inherent in the act of collecting itself. Our collector-patrons' libraries are extensive, and their books are well thumbed. They also aspire to purchase works of the highest quality and have consciously sought to train the "eye" to recognize the best of it, that is to educate their taste. The works in this show attest to their connoisseurship.

Self-education has led our collector-patrons to want to foster the education of others. Indeed, they consider the support of education a primary goal. They are interested in

museums not only as the final repositories of their collections but because they are educational institutions. This also seems to be peculiarly American. Traditionally, local, state, and federal governments have justified providing tax dollars to museums largely because of their educational activities.

Our collector-patrons' interest in sharing their art with young people is manifest in the educational institutions they support. Agnes Gund founded Studio in a School, which provides instruction by artists in New York City public schools. Children experience making art, which as a byproduct, improves their verbal skills, while artists earn some money and receive health care and insurance coverage. The extensive collection of Marieluise Hessel has become the core of the Center for Curatorial Studies in Art and Contemporary Culture, which she established at Bard College in upstate New York and which offers a multidisciplinary graduate program to train museum personnel.

The Kemper Museum of Contemporary Art, in Kansas City, Missouri, has an active outreach program. It sponsors an Artists-in-Residence Program that teams students with artists; and a Street Museum, which takes art into the community, and among other activities, features the art of high school students, demonstrations by artists, and a family festival of street painting by children. In order to make itself fully available to the public, the Kemper Museum does not charge admission. The Pattons are benefactors of the Ackland Art Museum, the museum of the University of North Carolina at Chapel Hill. Mary Patton founded the Docents Program at the Hirshhorn Museum and has been a director of the Executive Committee of the United States Association of Museum Volunteers. The Pattons are also active in the Anderson Ranch Arts Center near Aspen, Colorado, which runs an extensive arts workshop program.

All of our collector-patrons spoke to me of their responsibility to the art they cherished. They think of a work not as an object, like a table or a coffee cup, but more like a pet dog, or even a child. The upkeep of their paintings and sculptures and their future was of great concern. As Agnes Gund said, "[We] must take care of them since they will eventually belong to the public. This means we must manage the collection properly. . . maintain a clear inventory, and consider the many issues of conservation." Moreover, when works are loaned, the collector-patrons must ascertain whether the institutions provide "an adequate physical environment."[2] Our collector-patrons do not think of themselves as owners of the works they acquire, but as "custodians" or "conduits" who hold them in trust for the public institution where they will be best cared for and survive. This means the museum, not the auction block.

I asked our collector-patrons whether they gave their collections to museums in order to create monuments to themselves. Self-aggrandizement and claims for posterity did not interest them. Agnes Gund pointed out that she donated works to a dozen museums on a case-by-case basis according to their needs. ("I like to give where I can affect something."[3]) Among the museums that have benefited from her largesse are the Modern, Cleveland, Seattle, Hirshhorn, Whitney, Guggenheim, Fogg, National Gallery, and Oberlin's Allen Memorial Art Museum. Crosby Kemper said that his museum might be viewed as a bid for immortality, but that did not concern him. "Kansas City is my home. I love it." The city needed a museum of contemporary art and he built it. Bea Gersh said: "I was born here [in Los Angeles], and Phil went to UCLA." Mr. Gersh added: "We feel strongly that we want to give things back." As North Carolinians, the Pattons naturally gave their collection to their alma mater, which as they recall, had been consequential in their lives.

I was struck by the offhand modesty of our collector-patrons. Public service was just something that "is done." Nevertheless, they were proud of the collections they had assembled, or, as Jim Patton said, "satisfied" with them. But they were all aware that collection follows creation—and is secondary to it. Talking to Patton, I was reminded of a comment attributed to Henry Clay Frick. When asked whether he was proud to have acquired so many magnificent pictures, he replied, "No, I did not paint any of them."[4]

JUST AS THE FIVE COLLECTORS are honored in this exhibition because of their philanthropy, so the show itself aspires to a public-minded purpose. That purpose is to provide role models for other collectors, and to encourage their patronage.

1 Alfred H. Barr, Jr., *The G. David Thompson Collection of Twentieth Century Paintings and Sculptures* (New York: Parke-Bernet Galleries, 1966), n.p.

2 Agnes Gund, "The Art Ecosystem: Art as It Exists within a Private Collection," *Mortality Immortality: The Legacy of 20th-Century Art* (Los Angeles: The Getty Conservation Institute, 1999), p. 121.

3 Martin Filler, "Thoroughly Modern Aggie," *Vanity Fair*, November 1991, p. 70.

4 Quoted in Adrian Dannatt, "Review of Books: Collectors' Secrets," *Art in America*, June 1999, p. 39.

Collector-Patron Portraits and Paintings

including

excerpts from interviews with Irving Sandler

conducted Autumn 1999

BEA AND PHIL GERSH

California

MUSEUM AFFILIATIONS

Los Angeles County Museum of Art, California

The Museum of Contemporary Art, Los Angeles, California

Newport Harbor Art Museum, California

Pasadena Art Museum, California

Irving: How would you characterize your collecting mentality? Do you think you're driven, infatuated? Is it an obsession, an addiction, a pleasure—?

Bea: Collecting is a pleasure . . . but also a little bit of an addiction.

Phil: A good and worthy addiction. This contagious act of collecting, and, in turn, support for the museum, has been passed on to both our sons.

Bea: As the custodians of the works we collect, we feel that we have to give something back to the community.

Phil: Over the years, we have offered other collectors advice when they started, and we hope that *our* giving has encouraged others to do the same.

JACKSON POLLOCK (1912–1956)

No. 3, 1948. Oil and painted enamel on canvas affixed to Masonite, 30⅜ x 22½ inches

The Museum of Contemporary Art, Los Angeles. Partial Gift of Beatrice and Philip Gersh

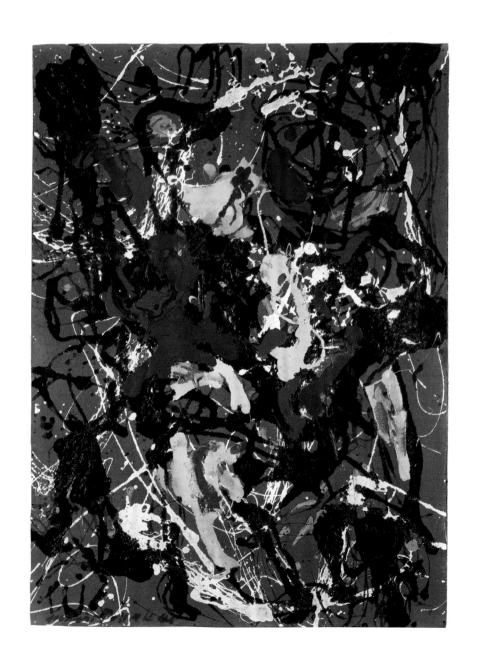

AGNES GUND
New York

Irving: Some collectors talk about a thrill in acquisition. A thrill in possession—

Agnes: I don't think that I am a real "possessor," or I wouldn't give away as much as I do . . . We will give a lot of things away—to ten or eleven museums. We want our works to make a difference and give to museums that could really benefit and couldn't afford to fill lacunae in their collections.

Photo of Agnes Gund by Timothy Greenfield-Sanders

ROY LICHTENSTEIN (1923–1997)
Masterpiece, 1962. Oil and magna on canvas, 54 x 54 inches
Collection of Agnes Gund
© Estate of Roy Lichtenstein

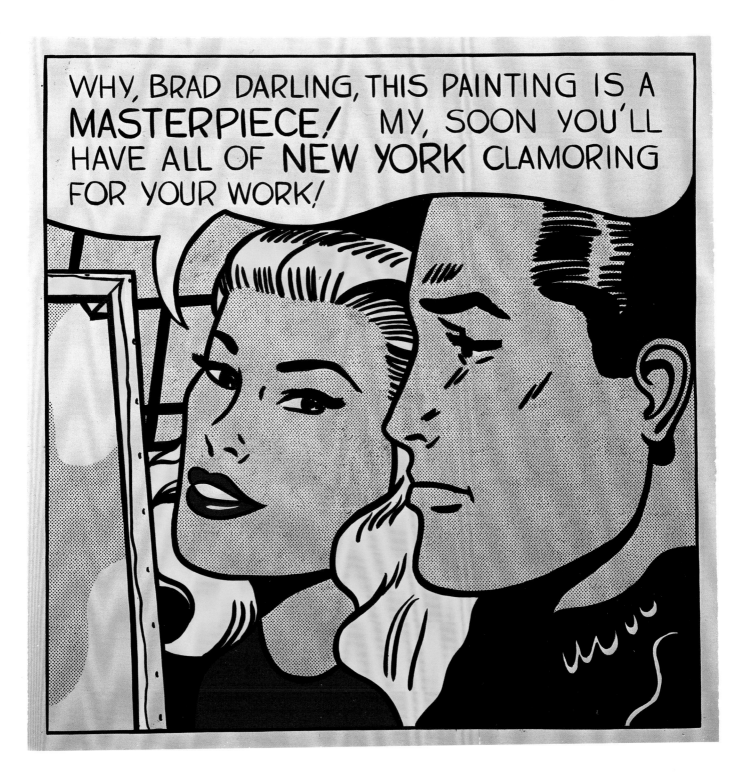

Wyoming and New York

MUSEUM AFFILIATIONS

Center for Curatorial Studies, Bard College, Annandale-on-Hudson,
 New York
The Museum of Contemporary Art, Los Angeles, California
The Museum of Modern Art, New York, New York
Whitney Museum of American Art, New York, New York

Marieluise: I can see my autobiography in my collection.

Irving: Why have you become a patron?

Marieluise: It's an obligation. I feel responsible for the afterlife of my
collection. And I enjoy giving my art away. Collecting and Bard have
become my work.

PHILIP GUSTON (1913–1980)
Solitary II, 1978. Oil on canvas, 68 x 80 inches
Marieluise Hessel Collection, on permanent loan to the Center for Curatorial Studies,
Bard College, Annandale-on-Hudson, New York

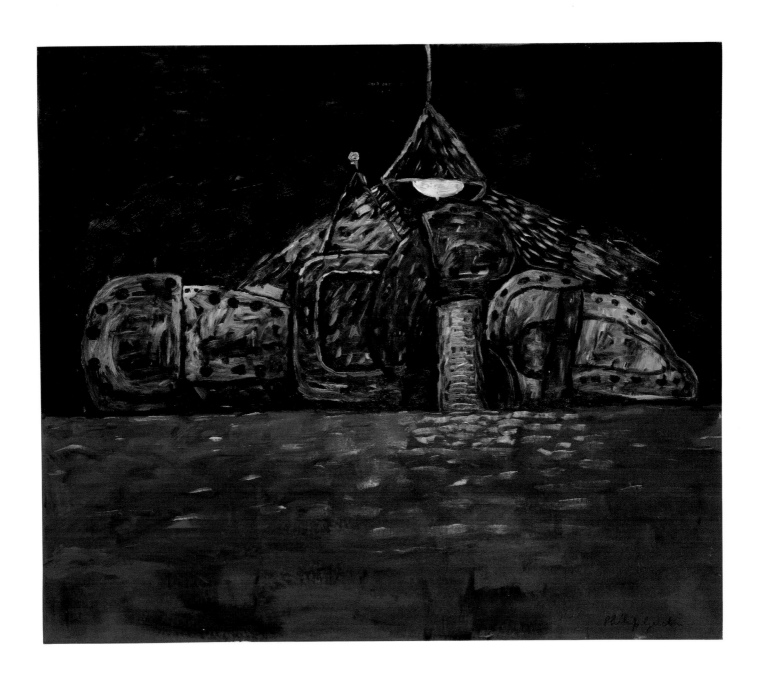

BEBE AND CROSBY KEMPER

Missouri

MUSEUM AFFILIATIONS

Addison Gallery of American Art, Phillips Academy, Andover,
 Massachusetts
The Albrecht-Kemper Museum of Art, St. Joseph, Missouri
Kemper Museum of Contemporary Art, Kansas City, Missouri
National Museum of American Art, Smithsonian Institution,
 Washington, D.C.
The Nelson-Atkins Museum of Art, Kansas City, Missouri

Irving: Why did you decide to give your collection to the public?
Why build a museum?

Crosby: I collect because I love it—and feel that we're a temporary
harbor for art. The good stuff should really end up in a museum . . .
where it's available to the public. Bebe and I wanted to share our col-
lection. My grandfather and dad taught me that money was not any-
thing in itself. It was only a means to an end, to do good with. My
dad didn't believe in inherited money. They left it all to foundations.
Our greatest pleasure is our museum.

FRANZ KLINE (1910–1962)
Untitled, c. 1957. Oil on canvas, 27⅜ x 37⅜ inches
Kemper Museum of Contemporary Art, Kansas City, Missouri, Bebe and Crosby
Kemper Collection, Gift of William T. Kemper Charitable Trust, 1999.14
© 2000 The Franz Kline Estate/Artists Rights Society (ARS), NY

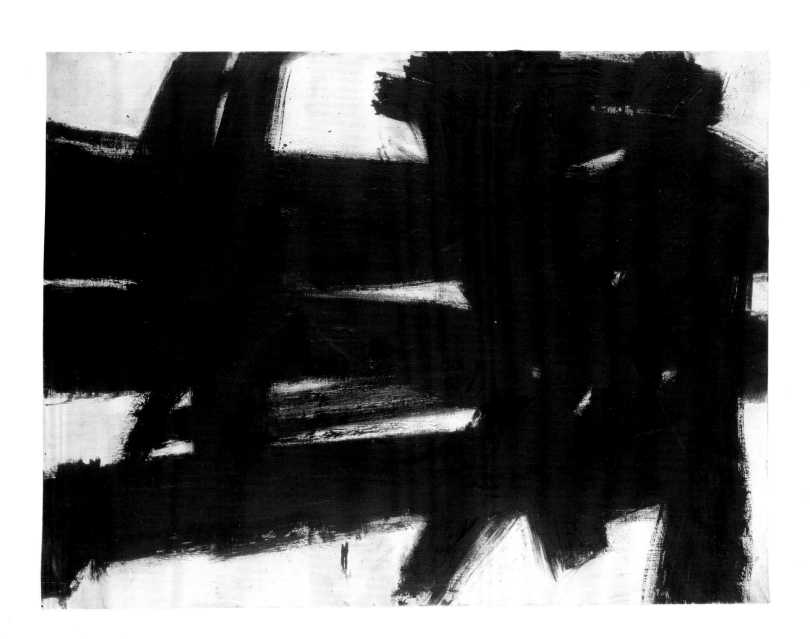

MARY AND JIM PATTON

Colorado and Arizona

MUSEUM AFFILIATIONS

Ackland Art Museum, University of North Carolina at Chapel Hill,
 North Carolina

Aspen Art Museum, Colorado

National Gallery of Art, Washington, D.C.

National Museum of Natural History, Smithsonian Institution,
 Washington, D.C.

Whitney Museum of American Art, New York, New York

Irving: Why do you want to give your collection away?

Mary: My generation and the generations before it felt that it was our duty.
If you loved and lived with works of art, then you want to share them with
others.

Jim: Yes. We are thankful for being able to collect this art and we'll give it
back to the world. I like the idea that these works that we have enjoyed over
the years will give pleasure to other people.

ADOLPH GOTTLIEB (1903–1974)
Ashes of Phoenix, 1948. Oil on canvas, 30 x 38 inches
Collection of Mary and Jim Patton
© Adolph and Esther Gottlieb Foundation/Licensed by VAGA, NY, NY

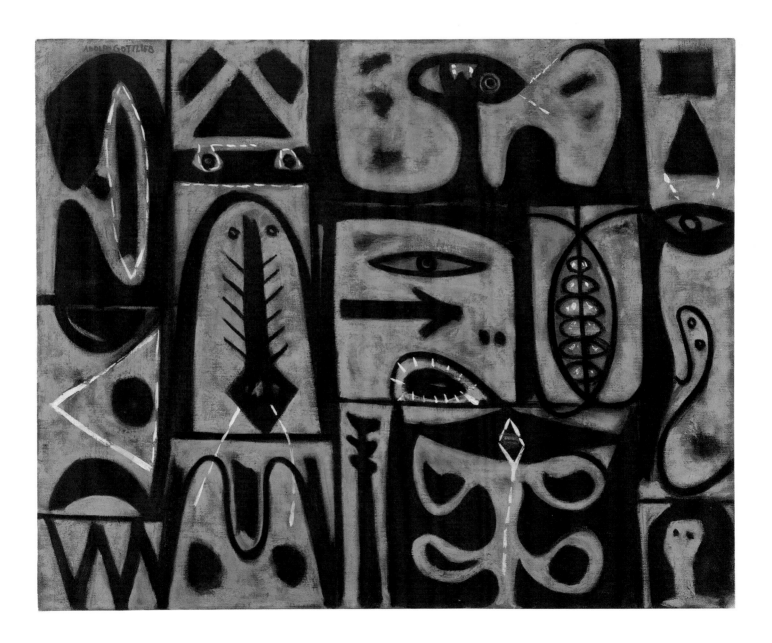

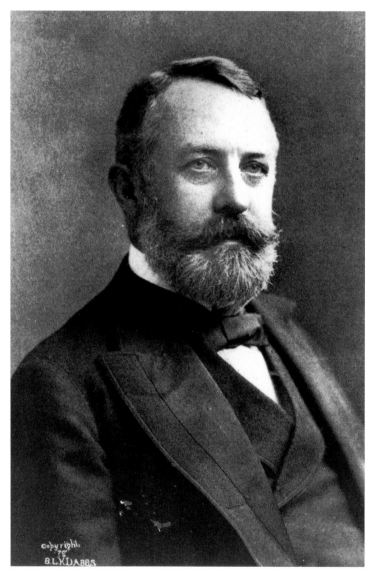

Henry Clay Frick, circa 1895.
Courtesy of Corbis-Bettmann

Profiles in Patronage

by DeCourcy E. McIntosh

WITHOUT ROYALTY, ARISTOCRACY, or an established church to bestow commissions, the young American republic had to wait for the most ambitious among its increasing number of prosperous citizens to discover the value of public art-patronage. To be sure, the professional training of artists was a civic concern at least as early as the 1790s, when leading citizens realized the necessity of developing native talent. But the art collector as patron took longer to emerge: the first real art museum in the United States did not open until 1842, when Daniel Wadsworth, the art collector and patron of Frederick Edwin Church, established the Wadsworth Atheneum in Hartford, Connecticut.

Wadsworth had inherited a large fortune from his father, and his wife was the daughter of the prominent artist John Trumbull. His leisured position and marital connections set him apart from another patron, a remarkable New Yorker whose rise in commerce and emergence as an influential art collector and patron constituted a template that would be replicated by future generations. Luman Reed, a wholesale grocer and dry-goods merchant, was born on a farm in Columbia County, New York. Once established in business in New York City, he began buying old master paintings as soon as his means allowed, around 1825. Early on, however, he discovered that he had been duped into accepting spurious attributions. Instead of abandoning art collecting, he redoubled his efforts—in American art, the arena in which he would make his mark. When Reed's house at 13 Greenwich Street was completed, by 1832, it included a two-room picture gallery on the top floor. There, visitors who had some sort of introduction could view his collection once a week, and artists and writers gathered frequently for exchanges on subjects of mutual interest. The gallery included a number of works, many of them remarkable, by such artists as Thomas Cole, William Sidney Mount, and Asher B. Durand. Although the gallery was never to form the basis of a successful museum (its collection is now in the New-York Historical Society), it is a striking example of art collecting and patronage in New York in the 1830s. It requires only a slight stretch of imagination to perceive in it a foreshadowing of The Frick Collection, which opened to the public in the 1930s.

It was a small but increasingly busy New York art world into which the French print publishers and art dealers Goupil, Vibert et Cie. injected themselves in 1846. Although dif-

ficult to prove, it seems likely that Adolphe Goupil and Théodore Vibert had been in contact with American artists or, at least, with European artists who had traveled in America, before their emissary, Michael Knoedler, ever landed in New York. From the moment it opened in the winter of 1848, the firm displayed a clear-eyed instinct for convincing Americans that by purchasing European art they were serving the national interest.

In effect, Goupil's engineered an acceptance of contemporary European art that would have the most profound consequences for art patronage in America, for it may truly be said that American art patronage and M. Knoedler & Co. (as Goupil's became known after 1857) grew up together. Indeed, by the mid 1860s, Knoedler's advantageous address, 772 Broadway, had become the destination for a steady stream of collectors from Boston, Buffalo, Baltimore, Philadelphia, Pittsburgh, Cincinnati, and, especially, New York. As the size of their art collections increased, many, particularly the New Yorkers, followed the precedent set by Luman Reed and added art galleries to their houses. Often of stern, Calvinist background, they felt morally obligated to share their art collections with the public and opened them on a regular basis. They also lent generously to exhibitions organized for charity. "It has become the mode to have taste," James Jackson Jarves wrote in 1863. "Private galleries in New York are becoming as

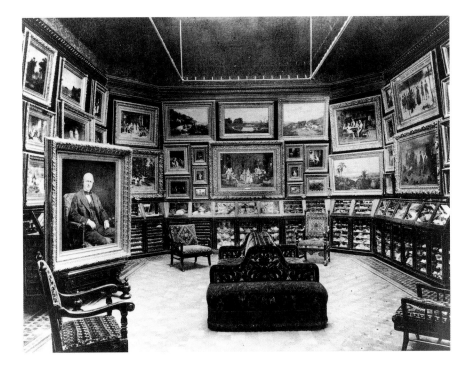

Robert L. Stuart house, 961 Fifth Avenue—a paradigm of New York art patronage, circa 1880. Many of the pictures in this view of Robert and Mary Stuart's private gallery are now in the collection of the New-York Historical Society. *Artistic Houses* (D. Appleton & Co., 1883–84)

common as stables." He might have added that opening one's gallery to the public and lending for charity were effectively becoming the norm for art patronage as well as practical ways of displaying "taste."

Though by no means the first of its kind in the city, *The New York Centennial Loan Exhibition of Selections from the Private Art Galleries*, the highlight of the summer of 1876, was certainly the largest display of collecting and patronage the city had witnessed. Three venues shared the event: the National Academy of Design, at Twenty-third Street and Fourth Avenue; The Metropolitan Museum of Art, in its rented quarters on West Fourteenth Street; and August Belmont's private gallery, at 109 Fifth Avenue. The National Academy exhibited more than four hundred paintings "by the most eminent painters of Europe and America" borrowed from some fifty New Yorkers. The Metropolitan showed 180 paintings from 11 private collections; and August Belmont, arguably the city's leading collector, displayed his own hoard. Although perhaps, from our viewpoint, all too predictable, the collections represented a wealth of art collecting and patronage.

The owner of more than half the paintings shown at the Metropolitan was its president, John Taylor Johnston, a lawyer and railroad head who by virtue of his liberality and probity exerted considerable influence over the course of patronage in the city.

Although his collection (housed in a gallery over the stable behind his house at Fifth Avenue and Eighth Street) would doubtless have been bequeathed to the Metropolitan, he was forced to sell it at auction in late 1876 because of business reverses. Despite this setback, Johnston remained a force on the Metropolitan's board until well into the 1880s. Perhaps his ultimate gift to the museum was the respect for patronage he instilled in his own family. His daughter, Emily, and her husband, Robert W. de Forest, became important benefactors to the Metropolitan in the early twentieth century, most notably as builders of the American Wing and, in Robert's case, as president of the board.

In 1846, the year Michael Knoedler arrived in New York, Catharine Lorillard Wolfe, a girl of eighteen, won a landscape by Jasper Francis Cropsey in the annual lottery of the American Art-Union. Somewhat later, her cousin, John Wolfe, steered her toward his primary interest, European painting. By 1870, Catharine had become an ardent client of M. Knoedler & Co. Some half-dozen of the nineteen paintings she bought from the gallery are still in the Metropolitan's permanent collection, including Bouguereau's *Breton Brother and Sister*, Gérôme's *Prayer in the Mosque*, and the melodramatic *Storm* by Pierre-Auguste Cot.

Wolfe was the only woman among the original subscribers to the Metropolitan in 1870, and at her death at age fifty-nine in 1887, she left her entire collection of one hundred twenty paintings and twenty-two watercolors to the museum "for the enjoyment and recreation of all who may frequent its rooms." She also provided an endowment fund of $200,000 for maintenance of the collection and for purchase of oil paintings "of acknowledged merit and superior excellence." No previous patron had bequeathed both a large collection and a purchase endowment.

Could Wolfe have imagined that, despite the provisions in her will stipulating a separate Catharine Lorillard Wolfe Collection gallery, the works she acquired eventually would be pared down and absorbed into the larger body of the Metropolitan's permanent collection? Would she have approved of the acquisitions she made possible? Such questions pale beside the actual fruits of her bequest. The best of the Wolfe collection has been preserved. The acquisitions funded by her bequest—Renoir's *Madame Charpentier and Her Children* and Ingres's portraits of Jacques-Louis Leblanc and his wife, for example—are among the most prized in the nineteenth-century painting collection. Finally, Catharine Lorillard Wolfe is respected as an art patron whose generosity surpassed her own interests and extended into perpetuity.

Luman Reed, the lenders to the Centennial Loan Exhibition, John Taylor Johnston, and Catharine Lorillard Wolfe represent a succession of collector-patrons who laid the groundwork for the great acts of patronage of the first half of the twentieth century. Reed's brick rowhouse on Greenwich Street may seem remote from the imposing, limestone Frick mansion occupying an entire block of Fifth Avenue, yet they are inextricably joined as links in the chain of American patronage that continues to shape the nation's great public collections.

This is not the place to acknowledge all the major collectors whose patronage is evident in American art museums. But should such an honor roll be compiled, it would reflect the fact that in America, in contrast to European countries, individual initiative and philanthropy have been the sole basis for the formation of museum collections. The Metropolitan Museum of Art resulted from the combined efforts of a group of individuals: John Taylor Johnston, Catharine Lorillard Wolfe, and their circle. Other American patrons chose to create whole museums independently, and it is three examples of this type of patron that will be discussed. Regrettably, space limitations prevent coverage of the larger number who deserve attention.[1]

Industry produced much of the wealth that fueled American collecting and patronage, and Pittsburgh, Pennsylvania, the archetypal American industrial city, brought forth three sons—Henry Clay Frick, Andrew Mellon, and Duncan Phillips—who made indelible marks as collector-patrons in the first half of the twentieth century: they will stand here for the many American patrons who founded museums as an outgrowth of their own art collections. Frick and Mellon were among the preeminent creators of Pittsburgh capital; and as their immense fortunes accumulated, they spent unsparingly in the cause of art patronage. Duncan Phillips, though merely one among many heirs to smaller fortunes, spent no less unsparingly of his capital to bring his own vision of an art museum into being.

Before leaving Pittsburgh in 1905, Frick had done much to encourage the fine arts, ultimately serving as treasurer of Carnegie Institute and lending liberally to the Institute's early shows. Once settled in New York, he joined the board of the Metropolitan—likely at the behest of its omnipotent chairman, J. Pierpont Morgan. Yet, in art as in business, Frick was essentially an individualist. His association with Andrew Carnegie made him very rich—richer than he would ever have been as an independent coke manufacturer in western Pennsylvania—yet he chafed under Carnegie's supreme authority and never overcame the feeling of lost autonomy that the merger of his coke company into

the giant Carnegie steel enterprise engendered. Reinforcing this sentiment was a belief (ultimately shared by Phillips, if not Mellon) that works of art are best appreciated in the tranquillity of a domestic setting, unobstructed by museum convention.

Frick collected prints—probably reproductive prints—while still a very young man. He also liked good clothes and expensive shoes and sometimes tried his hand at sketching. These are virtually the only existing clues to the origins of a lifelong collecting habit, but they suffice to suggest that the young Frick would have been an insatiable consumer of the best that the art establishments (and haberdasheries) of Pittsburgh had to offer. It would have been natural for him, for example, to wander into J. J. Gillespie's art gallery (founded in 1832), leaf through folios of prints imported from Knoedler, and covet gilt-framed agrarian scenes by local painters such as George Hetzel and Bryan Wall. A few prominent Pittsburgh businessmen had become Knoedler clients in the 1860s, and as Frick's prospering coke business brought him to town more and more often during the 1870s, he must have known of some of the collections being formed around him.

When he moved permanently to Pittsburgh in 1880, Frick owned so many prints that it took two days to hang them all in his rented rooms. Typical of his holdings, one may assume, were reproductive engravings published by Knoedler, such as the pair after George Boughton's *Priscilla* and *Evangeline* that he purchased in 1881. Still, thirteen years would elapse before he ventured to buy a painting from Knoedler. Meanwhile, he had journeyed to Europe, visiting museums with a trio of bachelor friends including the young Andrew Mellon, and had married, sired offspring, stepped into the leadership of Carnegie Steel, and settled into a home on the eastern perimeter of Pittsburgh. There he displayed a modest collection typical of its time and place: woodland landscapes and a still life by Hetzel, a double portrait of Adelaide Frick and her sister by Wall, and a few sentimental watercolors and oils purchased from Schaus and Sedelmeyer in New York and Wanamaker's in Philadelphia—in addition to all his prints.

Frick the prospering amateur applied himself to self-betterment by devouring sumptuous editions of illustrated art folios, such as *Art Treasures of America*, *Masterpieces of French Art*, and *Mr. Vanderbilt's House and Collection*, all of which were available from Pittsburgh importers. With the Vanderbilt book, he obtained for an extra $100 a set of twenty satin prints reproducing popular Salon paintings in William H. Vanderbilt's collection, and had them expensively framed and hung on his walls.

That first purchase of a painting from Knoedler—*Coming from the Garden* by Daniel Ridgway Knight—brought Frick into contact in 1894 with Charles Carstairs, who had recently joined the Knoedler gallery, and with Roland Knoedler, Michael's son, who had been managing the business since his father's death in 1878. If ever an initial contact succeeded, it was this one: Knoedler, especially, became a favored companion of the Frick family, as well as Frick's closest art advisor.

By 1900, Frick possessed seventy-one paintings, most of them acquired at Knoedler, and space was at such a premium on his walls that paintings hung from doors and in front of windows and even blocked fireplaces. The Fricks' first New York residence, the very Vanderbilt house extolled in the volume on the collector's shelves, offered much-needed space for expansion. After nearly ten years of living in this mausoleum-like building, he knew exactly what he wanted: a luxurious, well-lighted, permanently suitable background for the collection he knew would be public some day. Though undocumented, it is generally believed that he formulated his plan for The Frick Collection sometime during the development of the residence at one East Seventieth Street.

In contrast to the youthful enthusiast Henry Clay Frick, Andrew Mellon, his closest friend, blossomed late as an art collector. Andrew's son, Paul Mellon, always credited Frick with opening his father's eyes to art on their European tour in 1880. This is undoubtedly true, but the same Pittsburgh environment that so effectively influenced Frick eluded Mellon, who lived with his parents in their comfortable but inartistic home until he married at the age of forty-five. Mellon's first recorded art purchase, made in 1896, was in fact a duplicate of the portrait of his father, Judge Thomas Mellon, that Frick had commissioned the previous year.

Later in 1896, Mellon, probably with Frick's encouragement, purchased from Knoedler a large genre scene by the expatriate American artist Frank D. Millet, which he loaned to his club, having no place of his own in which to hang it. Between 1896 and 1902, he acquired twenty-seven more paintings, all from Knoedler, all safely within conventions upheld by Frick and other Pittsburgh collectors.

The tone of a letter from Carstairs, who held Mellon's trust much as Knoedler held Frick's, suggests the extent to which art aroused in Mellon a sensitivity to delicate beauty. "I thought of you the minute I bought it as a picture that would go straight to your heart," Carstairs wrote, offering Mellon a British portrait in 1906. "The dress is white, the sash and ribbons a pretty pink & the sky a lovely blue and the whole picture is full of

light." Mellon bought the portrait (*Miss Willoughby* by Sir Thomas Lawrence) for $50,000 and ultimately made it part of the founding collection of the National Gallery of Art.

In the early 1920s, while serving as Secretary of the Treasury, Mellon yielded to Carstairs's encouragement to secure pictures of the first rank, paying commensurate prices. By 1930, it was apparent that he was collecting for something more than his personal pleasure, having mooted an interest in founding a national gallery of art in Washington privately as early as 1927. But it was the most fabulous of all old master transactions that made Mellon's intentions clear. In 1930–31, he acquired twenty-one old master paintings from the Hermitage in Leningrad for a total of $6,654,000. Included in the complex deal arranged by the Matthiesen Gallery in Berlin, Colnaghi in London, and (because Mellon was a client) Knoedler in New York were *The Annunciation* by Jan Van Eyck and Raphael's *Alba Madonna*.

On December 22, 1936—just eight months before his death at the age of eighty-two—Mellon wrote to President Franklin D. Roosevelt, formally offering his collection along with a building and an endowment for a national gallery of art. Even though the Andrew W. Mellon Collection, unveiled to the public at the National Gallery's opening in 1941, amounted to an impressive 125 pictures, the gift Mellon made provided for a building vastly larger than would have been required to house his collection alone. Just as he had hoped, his paintings were soon joined by the Widener Collection and others, for as President Roosevelt stated at the dedication ceremony, Mellon was "a giver who has stipulated that the Gallery shall be known not by his name but by the Nation's."

No discussion of Andrew Mellon's patronage would be complete without mention of Mellon's children, Ailsa and Paul. Ailsa Mellon Bruce was responsible for (among other purchases) one of the National Gallery of Art's most important acquisitions: Leonardo da Vinci's portrait of Ginevra de' Benci. She also donated to the Gallery the entire Molyneaux collection of small canvases, mostly by the Impressionists, and joined her brother in funding construction of the Gallery's East Building.

As both steward and patron, Paul Mellon's impact upon the National Gallery of Art was hardly less than his father's. The Gallery's first president at age thirty-one, he served (with time off for military service in World War II) as trustee, president, and then chairman until his retirement forty-seven years later. He is remembered best, however, as the donor of exceptional collections of Impressionist and British art.

Although he made his first art purchase—George Stubbs's *Pumpkin with a Stable Lad*—at Knoedler's London gallery in 1936, Paul Mellon did not begin to collect in earnest until the late 1940s, when, with his wife as muse, he became seriously enamored of Impressionist and Post-Impressionist painting. When the National Gallery of Art celebrated its twenty-fifth anniversary with an exhibition entitled *French Paintings from the Collections of Mr. and Mrs. Paul Mellon and Mrs. Mellon Bruce*, loans from the Mellons included Cézanne's *The Boy in a Red Waistcoat* and Degas's *Steeplechase—the Fallen Jockey*, among other Impressionist masterpieces. After Mellon's death in 1998, the National Gallery held a memorial

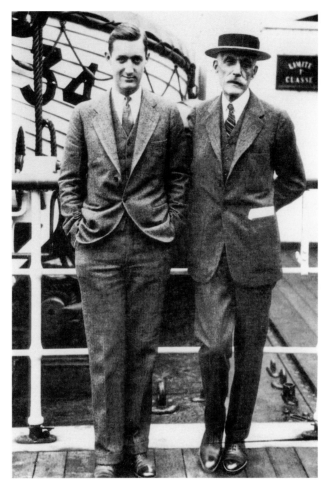

Andrew Mellon and his son, Paul, aboard ship on a transatlantic crossing sometime in the 1930s. © Washington Post, reprinted by permission of the D.C. Public Library

exhibition, concluding with the extraordinary collection of Degas's wax sculptures Paul Mellon had acquired from Knoedler in 1955; it was a fitting tribute to one of the greatest art connoisseurs and horse enthusiasts the nation has ever produced.

Mellon's British collection grew out of his love of the English countryside and a keen interest in horses. Single-handedly, he reawakened scholarly and public interest not only in Stubbs but in all of British art, eventually founding a center at Yale for its study and appreciation. Defending his practice of purchasing whole collections at one time, he wrote in 1992: "I have been a collector of collections when opportunity has arisen. This might seem a symptom of greed or at best an indiscriminate appropriation of widely different and incompatible congeries of books, pictures, sculptures, and other objects of art. To this charge I plead innocent, for in each purchase of a whole collection I have always had a probable or possible eventual repository in mind."

Mellon's bequest to the National Gallery added 73 items to the 913 Mellon donated during his lifetime. When combined with his benefactions to the Virginia Museum of Fine Arts and the Yale Center for British Art, his patronage dwarfs practically any other in the second half of the twentieth century, except, possibly that of Norton Simon. "Most of my decisions in life . . . are the result of intuition rather than mental analysis," he wrote with typical modesty. "I think I can truthfully say that I have not collected in order to hoard, and I hope the pleasure I have derived from my collecting activity is shared by those who now visit the National Gallery, the Yale Center for British Art, and the Virginia Museum of Fine Arts."

Paul Mellon has quoted his father explaining to a friend who asked about his motive for collecting art: "Every man wants to connect his life with something he thinks eternal." To the elder Mellon, the eternal invariably meant the great achievements of the past. Neither he nor his friend Henry Clay Frick showed the slightest inclination to ally themselves with anything else. This contrasted with the third son of Pittsburgh, Duncan Phillips, an evangelist for modern art and the founder and director of the nation's oldest surviving modern art museum.

Several factors contributed to Phillips's novel vocation. First, when Duncan was only seven, his parents left Pittsburgh for Washington, where they raised their two sons in a more cosmopolitan atmosphere than prevailed at the time in Pittsburgh. Second, he acquired a liberal education at Yale, immersing himself in the works of Walter Pater and writing art criticism heavily influenced by Pater's aestheticism. Finally, thirteen years after graduating from Yale, Phillips met and married Marjorie Acker, a practicing artist from the artistic Beal family. By all accounts, Marjorie Phillips was thereafter a full partner in all of her husband's artistic endeavors.

The only vestige of Phillips's conservative, Calvinist family background was his urge to preach—not about religion, but about art. As David Scott points out in a recent essay, Phillips's conversion to modern art was gradual. He "recoiled in horror" at the Armory Show and as late as 1914 referred to Cézanne and the Post-Impressionists as "a bunch of damned fools." Yet, as Robert Hughes asserts, "He wanted to be a dilettante in the full and proper sense of the word . . . a man who took educated pleasure in every field of culture, especially art."

Phillips and his brother began collecting art as single, young adults, after their parents allotted them an annual allowance of $10,000 for the purpose. Their initial acquisitions,

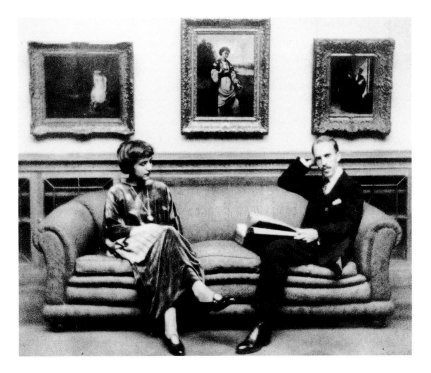

which they displayed in the family residence at 1600 Twenty-first Street, N. W., tended toward lyric romanticism. The sudden deaths of both James Phillips and Duncan's father in 1918 traumatized Duncan, and in the depth of his sorrow, he conceived the idea of a public art gallery in their memory. The Phillips Memorial Gallery opened for business in 1921 in two upper-story rooms of the Twenty-first Street house, after Phillips had begun to increase his purchases. Among the first new acquisitions was a small oil by Albert Pinkham Ryder, bought from Knoedler for $3,500. (This transaction occurred in the same month as Andrew Mellon acquired Frans Hals's *Portrait of Nicholas Berghem* from the gallery for $170,000.) Then, in 1920, he bought Daumier's *Three Lawyers*.

Phillips liked to assemble "units" of a given artist's work for in-depth study. For example, the original Ryder and Daumier purchases were the first of four paintings by Ryder and seven by Daumier to enter his collection. Ultimately, "units" developed around thirty-five artists, including Bonnard, Cézanne, Degas, Vuillard, Matisse, Roualt, Braque, Klee, Kokoschka, Prendergast, Davies, Augustus Vincent Tack, Sloan, Kent, Marin, Hartley, Dove, Avery, Knaths, De Staël, and Rothko, as well as Ryder and Daumier.

During the museum's early decades, Phillips also devoted considerable thought and resources to identifying the sources of modern art. Dissatisfied with conventional expla-

nations, he probed deeper and deeper into the history of art, writing prolifically and eventually selecting works by Corot, Delacroix, Ingres, Goya, and even Giorgione, whom he saw as key innovators.

The Phillips Collection began to assume its essential quality in the mid 1920s, when Alfred Stieglitz introduced Duncan and Marjorie Phillips to the work of Arthur Dove and John Marin. Soon Stieglitz had converted the couple to modernist American art of the type he favored. At around the same time, the Phillipses acquired Renoir's *The Luncheon of the Boating Party,* in the hope—which was to be amply fulfilled—that it would attract the public to the museum.

In his early manifesto, *A Collection in the Making* (1926), Phillips took pains to distinguish his institution from conventional museums, claiming as his "constant aim" not merely to exhibit "but also to interpret beauty in art . . . and gradually to popularize what is best, more particularly in modern painting, by novel and attractive methods of exhibition." As attested to by this statement, Phillips's avowed dedication to the interpretation of art is what lent his patronage its modern flavor. As a collector and museum director, he was thoroughly ingenuous, eager to defend his point of view without fear of ridicule and unflagging in his effort to convince his visitors to open their eyes to new artistic perceptions. Thirty-five years after his death, his galleries still reverberate with the visual dialogue he began.

In our day, when to form a collection in the vein of Frick and the Mellons (or Norton Simon or John Paul Getty) is impossible, a patron's capacity to enlarge the public's perceptions of what art is and what it can be is more valuable to society than ever before. Although we may no longer have to rely upon collectors to introduce art to us in the way that Reed and the founding fathers of the Metropolitan literally introduced it to their contemporaries, the collector who shares his or her aesthetic convictions with the public, either by giving works to museums or by lending them to exhibitions, or both, plays a vital role in contemporary American cultural life.

1 . The omission in this essay of J. Pierpont Morgan is particularly regrettable. However, Jean Strouse's thorough account of Morgan's prodigious collecting and patronage published in *The Metropolitan Museum of Art Bulletin* (Winter 2000) leaves nothing to be desired. It is worth noting that Morgan belonged to the tradition of New York art patronage begun with Luman Reed. His first wife was the daughter of Reed's son-in-law and partner, Jonathan Sturges, who was a founding father of The Metropolitan Museum of Art. Morgan's ascent to the presidency of the Metropolitan (1904–13) brought Reed's influence into the twentieth century.

New York November 1911
13

51 ³⁰/₃₆ ¹/₄	H. C. Frick	Pride's Crossing Mass.		
12208 ¹/₂₂ ¹/₃	Ptg. by Jan ver Meer of Delft 18 x 20 c The Soldier & the Laughing Girl			$225000

This picture is mentioned in C. Hofstede
de Groot's Catalogue of "Dutch Painters" 1907,
Vol. I, pages 599, 600 No. 39. It is also re-
produced in his portfolio on ver Meer, plate 27,
Mentioned in Van Zype's book on this artist,
(Brussels 1907) p. 93, and in the Outlook
Magazine for March 1910, p. 485, in an article
on ver Meer by E. V. Lucas.
Referred to by W. Burger in an article on "Van der
Meer de Delft" published in the Gazette des
Beaux Arts 1866, Vol. XXI, p. 462 and on page
548, where it is No. 7 in the Catalogue Raisonné
This work is No. 7 on Havard's list. It was en-
graved by Jules Jacquemart (See Bryan's
Dictionary of Painters and Engravers Vol. III p. 104)
and is also mentioned in Bryan's
Dictionary in a list of his works, Vol V, p. 289
Exhibited at the Burlington Fine Arts Club 1900 No. 18
Exhibited in the Grafton Gallery 1909-10, London
on behalf of the National Loan Coll. in aid
of the National Gallery funds, No. 50 p. 71 and
reproduced in the Catalogue.
Sold in Amsterdam May 16, 1696 No. 11, on
which occasion 21 of ver Meer's paintings
were disposed of in an anonymous Sale.
For further reference see the Burlington Mag-
azine of December 1910.
In 1866 (W. Burger) it was in the Coll. of
Leopold Double, who bought it at a London
Sale. It was not in the Demidoff Coll. as
Havard says. See reference de Groot's
"Dutch Painters". Sold in Collection of
Leopold Double, Paris May 30, 1881

Knoedler & Company
sales book illustrating
1911 sale of a painting
by Vermeer to Henry
Clay Frick.
Knoedler & Company
Archive

PAINTINGS IN THE EXHIBITION

BEA AND PHIL GERSH

HANS HOFMANN (1880–1966)
Polar Caves, 1954
Oil on canvas
50 x 40 inches

ELLSWORTH KELLY (b. 1923)
Untitled, 1962
Acrylic on canvas
32 x 23 inches

WILLEM DE KOONING (1904–1997)
Two Women, 1949
Oil on paper mounted on board
16 x 19¾ inches

JACKSON POLLOCK (1912–1956)
No. 3, 1948
Oil and painted enamel on canvas
 affixed to Masonite
30⅜ x 22½ inches

MARK ROTHKO (1903–1970)
Untitled, 1959
Oil on paper mounted on board
28¼ x 20¾ inches

AGNES GUND

JASPER JOHNS (b. 1930)
Savarin, 1977
Pencil and crayon on frosted Mylar
37 x 32¼ inches

ROY LICHTENSTEIN (1923–1997)
Masterpiece, 1962
Oil and magna on canvas
54 x 54 inches

BRADLEY WALKER TOMLIN (1899–1953)
Number 15, 1953
Oil on canvas
54 x 72 inches

CY TWOMBLY (b. 1928)
Untitled (Rome), 1961
Oil, crayon, and graphite on canvas
49½ x 57¼ inches

MARIELUISE HESSEL

SAM FRANCIS (1923–1994)
Honeyed, 1957
Oil on canvas
72 x 41 inches

PHILIP GUSTON (1913–1980)
Solitary II, 1978
Oil on canvas
68 x 80 inches

ALEX KATZ (b. 1927)
Ada in Blue House Coat, 1959
Oil on canvas
80 x 50¼ inches

AGNES MARTIN (b. 1912)
Untitled (#21), 1988
Acrylic and pencil on canvas
72 x 72 inches

BEBE AND CROSBY KEMPER

ROMARE BEARDEN (1914–1988)
Family, 1971
Paint, photographs, paper, fabric, and
 collage on paper mounted on board
22½ x 25¾ inches

HELEN FRANKENTHALER (b. 1928)
Coral Wedge, 1972
Acrylic on canvas
81½ x 46½ inches

FRANZ KLINE (1910–1962)
Untitled, c. 1957
Oil on canvas
27⅜ x 37⅜ inches

ROBERT MOTHERWELL (1915–1991)
Bordeaux Summer, 1973
Acrylic, collage, and charcoal on board
37 x 25 inches

FAIRFIELD PORTER (1907–1975)
Wheat, 1960
Oil on canvas
33½ x 33⅝ inches

WAYNE THIEBAUD (b. 1920)
Flowers, 1962
Oil on canvas
30 x 24 inches

MARY AND JIM PATTON

MILTON AVERY (1885–1965)
Seaside Strollers, 1963
Oil on canvas board
22 x 28 inches

RICHARD DIEBENKORN (1922–1993)
Untitled, 1949
Oil on canvas
48 x 41 inches

ADOLPH GOTTLIEB (1903–1974)
Ashes of Phoenix, 1948
Oil on canvas
30 x 38 inches

DAVID PARK (1911–1960)
Bus Stop, 1952
Oil on canvas
36 x 34 inches

COLLECTOR-PATRONS PROFILED IN THE ARCHIVAL EXHIBITION

with institutions that have greatly benefited from their gifts of art

BLANCHE ADLER AND SAIDIE ADLER MAY
The Baltimore Museum of Art, Maryland

WALTER CONRAD AND LOUISE STEVENS ARENSBERG
Philadelphia Museum of Art, Pennsylvania

ALBERT C. BARNES
Barnes Foundation, Merion, Pennsylvania

LILLIE P. BLISS
The Museum of Modern Art, New York, New York

ROBERT STERLING AND FRANCINE CLARK
Sterling and Francine Clark Art Institute, Williamstown,
Massachusetts

STEPHEN CARLTON CLARK
The Metropolitan Museum of Art, New York, New York;
Yale University Art Gallery, New Haven, Connecticut;
and elsewhere

KATHERINE SOPHIE DREIER
Yale University Art Gallery, New Haven, Connecticut;
and elsewhere

JACOB EPSTEIN
The Baltimore Museum of Art, Maryland

CHARLES LANG FREER
Freer Gallery of Art, Washington, D.C.

HERBERT GREER FRENCH
Cincinnati Art Museum, Ohio

HENRY CLAY FRICK
The Frick Collection, New York, New York; Frick Art &
Historical Center, Pittsburgh, Pennsylvania

HENRY OSBORNE AND LOUISINE ELDER HAVEMEYER
The Metropolitan Museum of Art, New York, New York

AARON AUGUSTUS HEALY
Brooklyn Museum of Art, New York

GEORGE A. HEARN
The Metropolitan Museum of Art, New York, New York

JAMES J. AND MARY HILL
The Minneapolis Institute of Arts, Minnesota

COLLIS P., ARABELLA, HENRY EDWARDS, AND
ARCHER M. HUNTINGTON
The Hispanic Society of New York, New York; Huntington
Library, Art Collections, and Botanical Gardens, San Marino,
California; The Metropolitan Museum of Art, New York,
New York; and elsewhere

SAMUEL H. KRESS
National Gallery of Art, Washington, D.C.; and elsewhere

ADOLPH LEWISOHN AND SAMUEL A. LEWISOHN
The Metropolitan Museum of Art, New York, New York;
The Museum of Modern Art, New York, New York;
National Gallery of Art, Washington, D.C.

HENRY P. MCILHENNY
Philadelphia Museum of Art, Pennsylvania

Andrew W. Mellon
National Gallery of Art, Washington, D.C.
and Paul Mellon
National Gallery of Art, Washington, D.C.; Virginia Museum
of Fine Arts, Richmond, Virginia; Yale Center for British Art,
New Haven, Connecticut; and elsewhere

J. Pierpont Morgan
The Metropolitan Museum of Art, New York, New York;
The Pierpont Morgan Library, New York, New York;
and elsewhere

Potter and Bertha Honoré Palmer
The Art Institute of Chicago, Illinois

Duncan Phillips
The Phillips Collection, Washington, D.C.

Martin Antoine Ryerson
The Art Institute of Chicago, Illinois

Charles Phelps and Anna Sinton Taft
Taft Museum, Cincinnati, Ohio

Robert Hudson Tannahill
The Detroit Institute of Arts, Michigan

Gertrude Vanderbilt Whitney
Whitney Museum of American Art, New York, New York

P.A.B. Widener and Joseph Widener
National Gallery of Art, Washington, D.C.

Catharine Lorillard Wolfe
The Metropolitan Museum of Art, New York, New York

ACKNOWLEDGMENTS

Knoedler & Company owes special thanks to those individuals who, on behalf of the collector-patrons, facilitated all aspects of the loan process: for Bea and Phil Gersh, Robert Hollister and Elizabeth Bradley, of The Museum of Contemporary Art, Los Angeles, and Denise J. Vetter of The Gersh Agency; for Agnes Gund, Jamie Bennett and Arabella Ogilvie-Makari; for Marieluise Hessel, Marcia Acita of the Center for Curatorial Studies, Bard College, and Gretchen Elkins; for Bebe and Crosby Kemper, Dan Keegan, Dana Self, and Dawn Giegerich of the Kemper Museum of Contemporary Art and Tonya Whetsel of UMB Bank, N.A.; for Mary and Jim Patton, Eileen Holway of Patton Boggs LLP.

Much of the material for the archival portion of this exhibition has been drawn from the rich holdings of the Knoedler Archive and Library, however, we are also indebted to a number of generous lenders of artwork and original archival material: The Baltimore Museum of Art, Century Association Archives Foundation, Sterling and Francine Clark Art Institute, Freer Gallery of Art, The Frick Collection, the Frick Art & Historical Center, the Frick Art Reference Library, DeCourcy E. McIntosh, The Metropolitan Museum of Art, The Museum of Modern Art. The Old Print Shop, The Phillips Collection, Procter & Gamble Company, Arthur M. Sackler Gallery, and Union League Club.

We owe a debt of gratitude to the generosity of The Frick Collection and the Frick Art Reference Library. Their commitment to the art community at large has allowed us to turn to them in so many instances. In particular, for their help with this project, we wish to thank Joyce Bodig, Susan Galassi, Rebecca Rex, Heidi Rosenau, William G. Stout, and Maglena Zapreva-Kirkbride of The Frick Collection and Patricia Barnett, Sally Brazil, Inge Reist, and Don Swanson of the Frick Art Reference Library.

In a similar spirit, Rebecca Rabinow of The Metropolitan Museum of Art has been extraordinarily generous in sharing with us her research on Catharine Lorillard Wolfe.

Special thanks to Tiffany Lee, Alexandra Partow, and Heather Pesanti at Jeanne Collins & Asssociates for their efforts on behalf of this project. And many thanks to our editor, Stephanie Salomon, for her expertise.

Many individuals assisted us in researching their holdings and in obtaining materials for inclusion in this exhibition: Brian Allen, Sterling and Francine Clark Art Institute; Barbara Bernard, National Gallery of Art; Lisa Blackburn, Huntington Library, Art Collections, and Botanical Gardens; Ruth Louise Bohan; Gerald Bolas, Ackland Art Museum; Stacy Bomento, Philadelphia Museum of Art; Jennifer Bossman, Yale University Art Gallery; Jennifer Bott, The Museum of Modern Art; David Brooke, Sterling and Francine Clark Institute; Jennifer Bryan, Maryland Historical Society; Ellin Burke, Museum of the City of New York; Terry Carbone, Brooklyn Museum of Art; Mikki Carpenter, The Museum of Modern Art; Mona Chapin, Cincinnati Art Museum; Conna Clark, Philadelphia Museum of Art; William K. Clark, Cincinnati Art Museum; Linda Clous, The Phillips Collection; Michael Conforti, Sterling and Francine Clark Art Institute; Debbie Cotavas, The Pierpont Morgan Library; Betty Davis, The Detroit Institute of Arts; Claire Dienes, The Museum of Modern Art; Erin Donovan, The Baltimore Museum of Art; Michelle Elligott, The Museum of Modern Art; Jay M. Fisher, The Baltimore Museum of Art; Thomas Grisschkowsky, The Museum of Modern Art; Mendy Gunter, Enoch Pratt Free Library;

Jonathan Harding, Century Association Archives Foundation; Marjorie Leslie Harth; Claire Hendricks, Timmins Museum and National Exhibition Centre; Colleen Hennessey, Freer Gallery of Art; Margo Hobbs; Elizabeth Hopkin, The Columbus Museum of Art; Susan Hudson, Taft Museum; Ruth Jansen, Brooklyn Museum of Art; Deborah Johnson, Barnes Foundation; Sylvia Inwood, The Detroit Institute of Art; Mattie Kelley, Sterling and Francine Clark Art Institute; Chris Ketcham, The Phillips Collection; Jeff Korman, Enoch Pratt Free Library; Deborah Labatte, The Minneapolis Institute of Arts; Marguerite Lavin, Museum of the City of New York; Arthur Lawrence, Union League Club; Lisa F. Leibfacher, Ohio Historical Society; Nanette V. Maciejunes, The Columbus Museum of Art; Juliann D. McDonough, Addison Gallery of American Art; Maureen Melton, Museum of Fine Arts, Boston; Brad Nugent, The Art Institute of Chicago; Caroline Nutley, Chicago Historical Society; John Pemberton, The Mariners' Museum; Nancy Press, The Baltimore Museum of Art; Jennifer Reis, Cincinnati Art Museum; Edward M. Rider, Procter & Gamble Company; Anne G. Ritchie, National Gallery of Art; Alyssa Rosenberg, Minnesota Historical Society; Timothy Rub, Cincinnati Art Museum; Katharine Salzmann, Morris Library, Southern Illinois University at Carbondale; Naomi Sawelson-Gorse; Hampton Smith, Minnesota Historical Society; Martha Smith, Freer Gallery of Art; Kristen Spangenberg, Cincinnati Art Museum; Adam Schiesl, The Art Institute of Chicago; Amber Lee Stafford, Cincinnati Art Museum; Nancy Stanfield, National Gallery of Art; Paul Spencer Sternberger; Scott Thompson, Arthur M. Sackler Gallery; Linda Tompkins-Baldwin; Gilbert T. Vincent, New York State Historical Association; Suzanne Warner, Yale University Art Gallery; Deborah S. Webb, The Art Institute of Chicago; Nicole Wells, The New-York Historical Society; Justin White, Corbis Images; and Julie Zeftel, The Metropolitan Museum of Art.

Those of us who have been privileged to spend most of our time on this project in recent months wish to thank our colleagues at Knoedler & Company: Frank Del Deo, Associate Director, oversaw the design and production of the catalogue; Jennifer Mulhearn facilitated many organizational aspects of the project; Peter Sansone, Chief Financial Officer, and the accounting department staff—Ruth Blankschen, Brenda O'Boyle, and Catherine McCormick—were consistently gracious and helpful in enabling the project to run smoothly; Helen Crosby Smith, Registrar, coordinated and supervised the loans, with assistance from our shipping department—Mario Borja and Joseph Stephan; Edye Weissler, Archivist and Librarian, with assistance from Madeleine Sentner and Anne Fischer, was indispensable in all aspects of the research. Extra work fell on the shoulders of all the staff, and for that we owe additional thanks to Jaime Andrade, Erin Rother, and Waqas Wajahat.

Finally, a word of thanks to our President and Director, Ann Freedman. Taking an introspective pause to turn a business into a "not-for-profit" environment is an extremely rare and precious privilege. This is not the first time Ann Freedman has given that privilege to her staff and her public. Her passion for all that is about art, her ebullient sense of adventure, and her enthusiastic regard for scholarship and history make her an unusual and inspiring leader. She has conceived this exhibition, sacrificed for it, and nurtured it—from *alpha* to *omega*.

Melissa De Medeiros

13

61	30 36	H. C. Frick	Pride's Crossing Mass.	
2408	13 275	Ptg. by Jan Ver Meer of Delft 18×20c The Soldier + the Laughing Girl		$22500

"This picture is mentioned in C. Hofstede de Groot's Catalogue of "Dutch Painters" 1907, Vol. I, pages 599, 600 No. 39. It is also reproduced in his portfolio on Ver Meer, plate 2, Mentioned in Van Zype's book on this artist, (Brussels 1907) p. 93, and in the Outlook Magazine for March 1910, p. 485, in an article on Ver Meer by E. V. Lucas.

Referred to by W. Burger in an article on "Van der Meer de Delft" published in the Gazette des Beaux Arts 1866, Vol. XXI, p. 462 and on page 548, where it is No. 7 in the Catalogue Raisonne

This work is No. 7 on Havard's list. It was engraved by Jules Jacquemart (see Bryan's Dictionary of Painters and Engravers Vol. III p. 101, and is also mentioned in Bryan's